EX LIBRIS

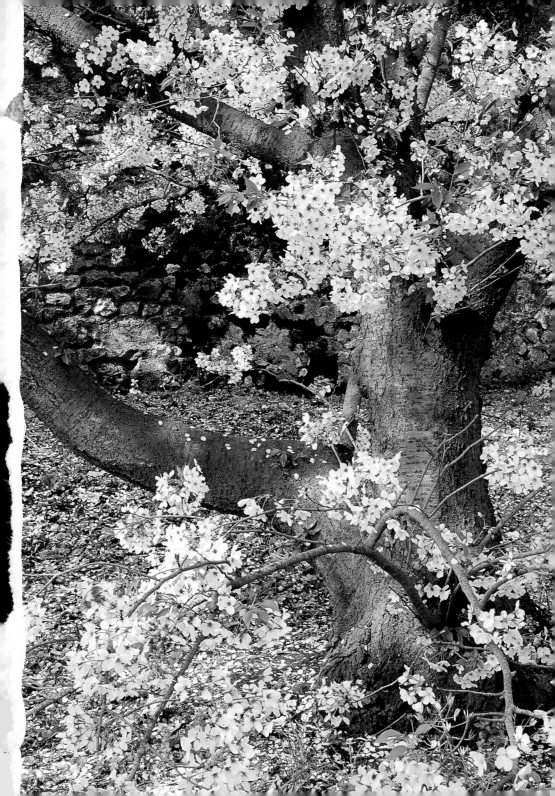

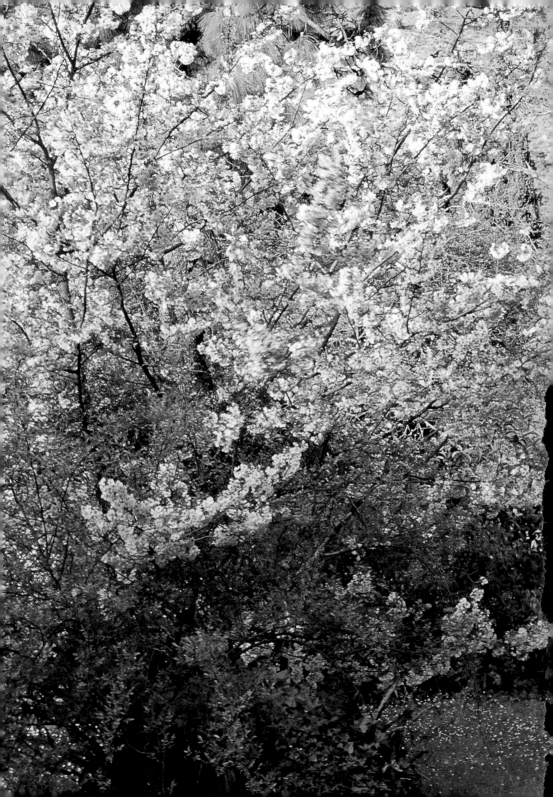

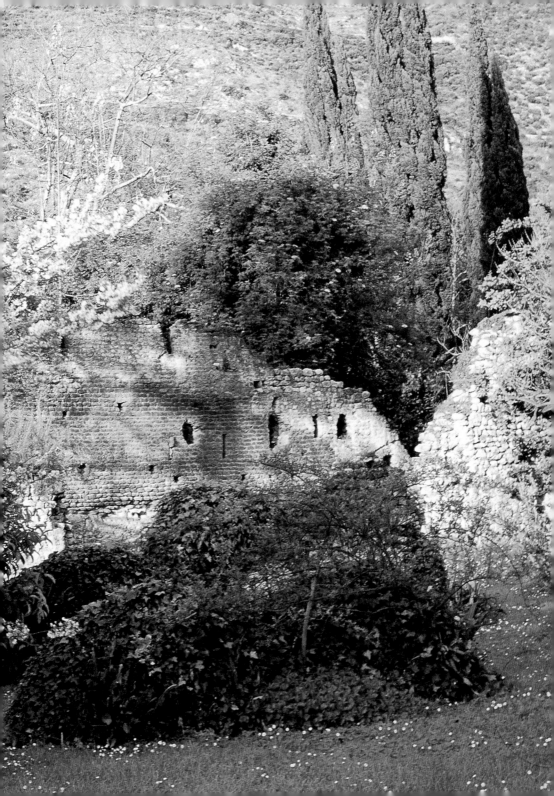

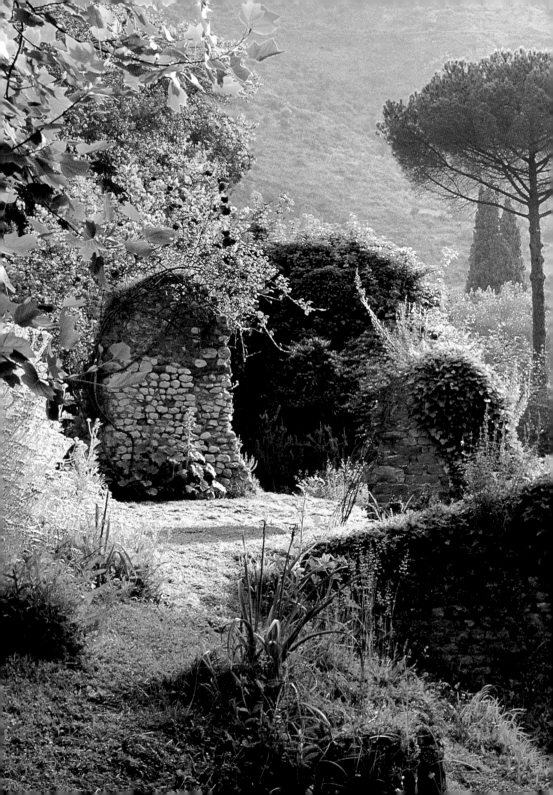

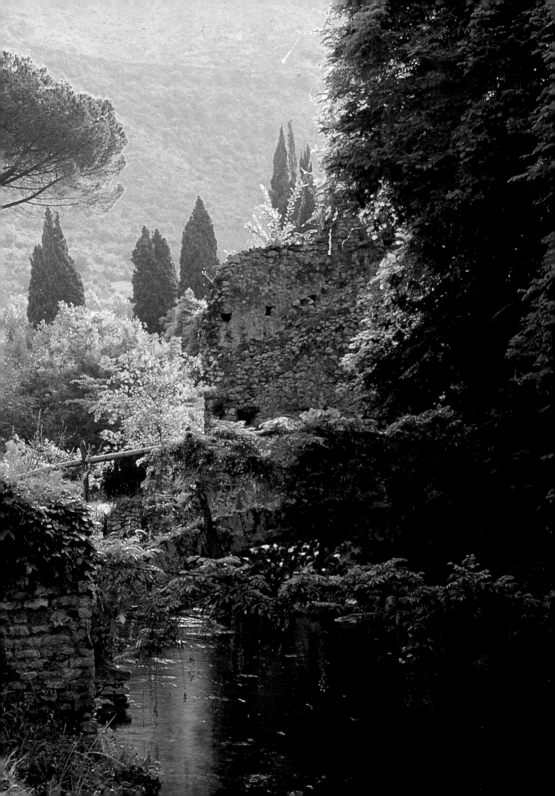

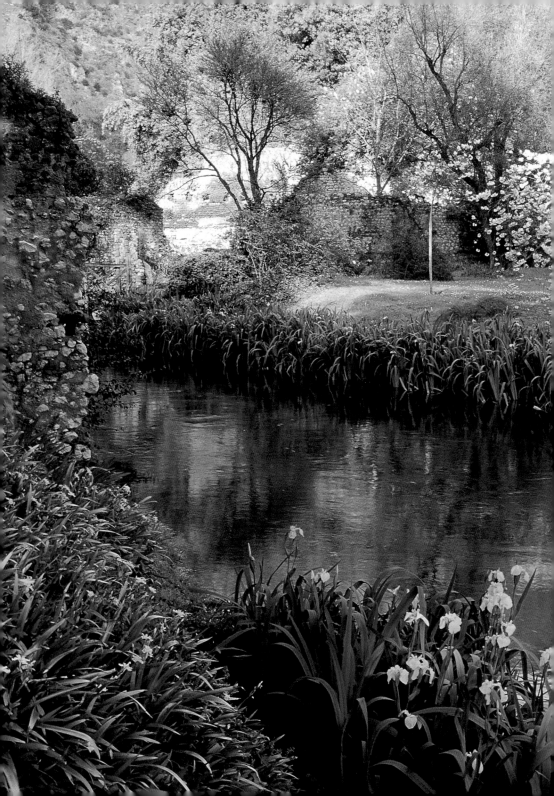

Photographs by Claire de Virieu

Text by Lauro Marchetti

and translation by Esme Howard

Ninfa

A Roman Enchantment

The Vendome Press

New York

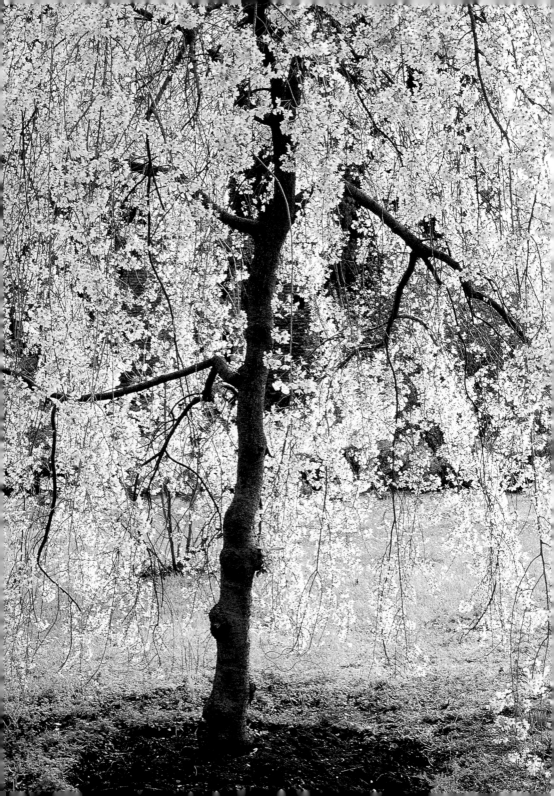

Contents

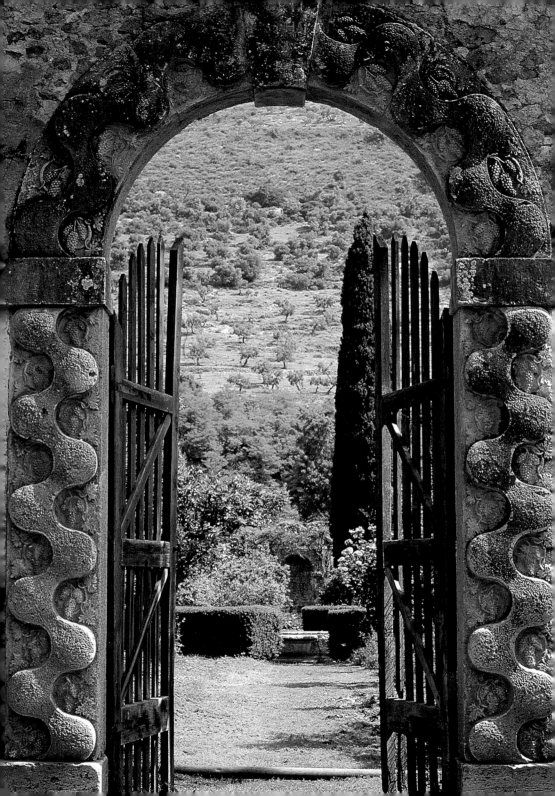

An Overview

The internationally renowned garden of Ninfa is situated some forty-five miles (seventy kilometers) southeast of Rome and fifteen miles (twenty-five kilometers) from the sea in the province of Lazio. The garden was laid out in the 1920s among the ruins of the small medieval town of Ninfa, which was founded in the eighth century and destroyed by the inhabitants of hostile neighboring towns in 1381.

For most of its history Ninfa and the surrounding land have been the property of the venerable Caetani family. The town itself was built at the foot of the Lepini Mountains next to a small lake fed by springs of ice-cold water. The building of the town and, much later, the creation of the garden in that place were motivated largely by the abundance and purity of the waters, which have not only inspired poets and artists,

For captions of previous illustrations, see page 80. The alluring arch, *opposite*, leads to an enclosed garden. *Above*, the decorative pattern on the stone is based on the Caetani coat of arms.

but from as early as the eighth century were recognized for their economic and strategic potential.

Ninfa is exposed to the south but protected from the north by the mountains. It thus avoids the cold northerly winds, while capturing and storing in its hard limestone rocks the incoming warmth of the Mediterranean. Visitors are often surprised to find a garden so green, luxuriant, and full of life in so dry a climate, but it is this combination of favorable weather, abundant water, and the creative genius of man over the centuries, that makes Ninfa unique.

The earth at Ninfa is rich, well drained, moist, and alkaline—conditions that make plants grow rapidly. The hot summer temperatures and moisture also permit rapid acclimatization of a wide variety of such tropical and other plants from extreme climates as the Arolla pine from the high mountains of the Alps and the Casuarina from Madagascar.

The garden was conceived and developed by the last three generations of the Caetani family and is now one of several country properties owned and administered by the Fondazione Roffredo Caetani. It is loved and admired by thousands of people from all over the world, not only for its singular atmosphere but also as a paradigm of conservation and protection. The strict rules laid down for public visits have made it possible to

12

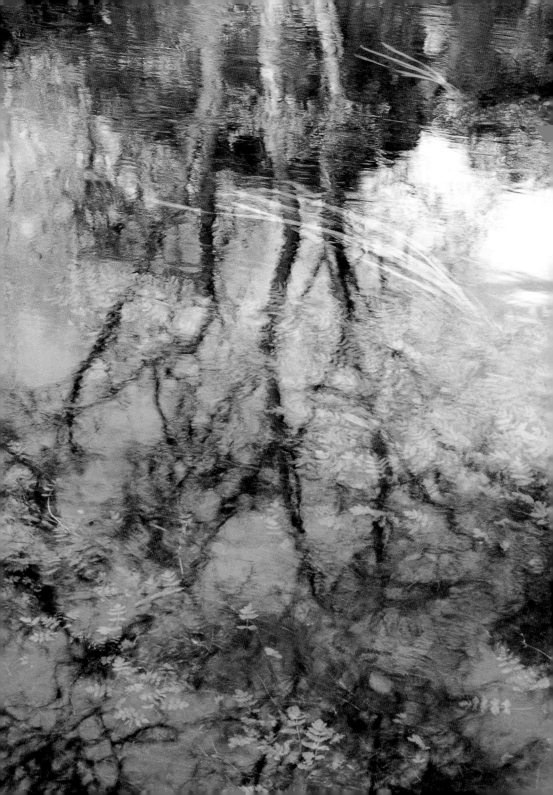

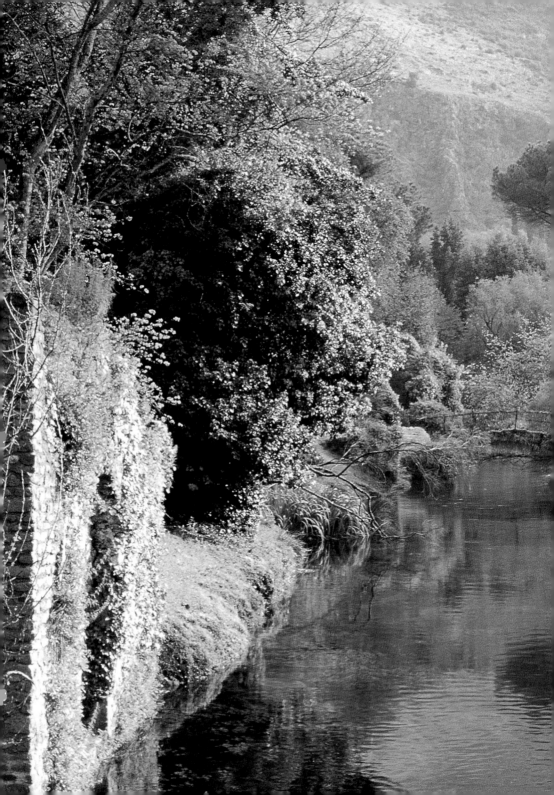

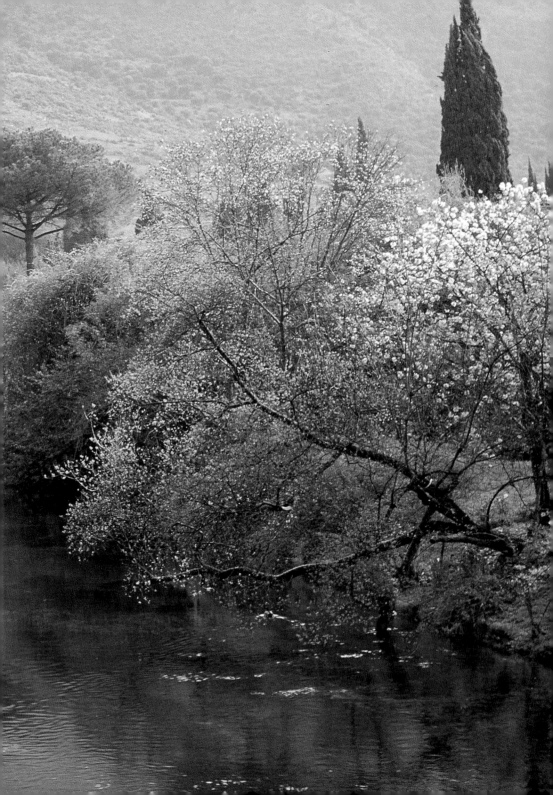

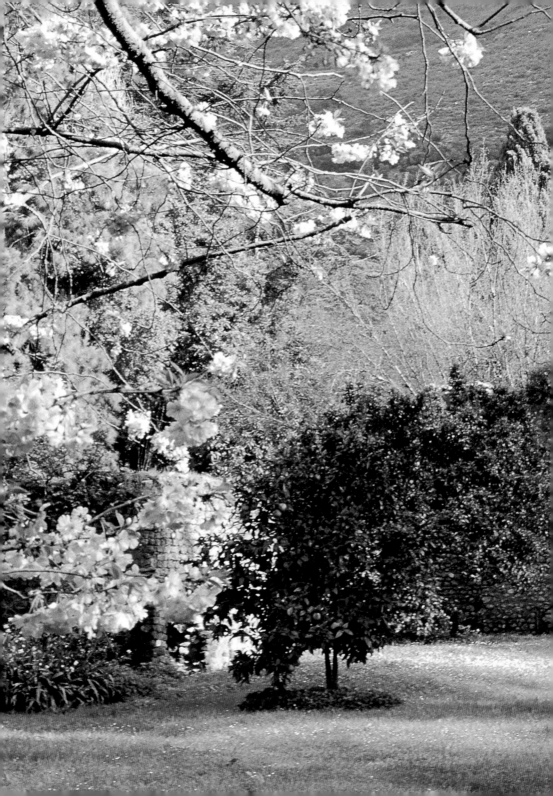

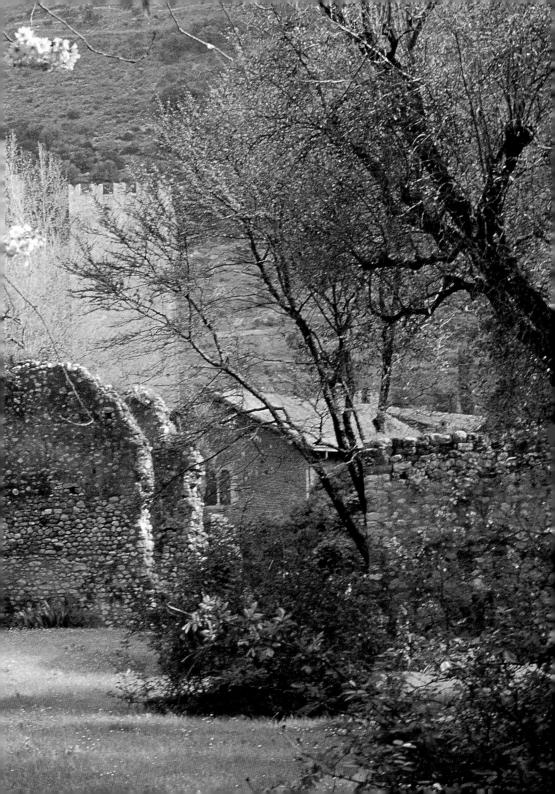

conserve not only the harmony and integrity of the whole garden but also the traditional values bequeathed to it by the last Caetani owners.

In the running of the garden today, as always, much attention is given to the balance between flora and fauna, between water, historic monuments, and man himself. To achieve this it has always been necessary to reduce to a minimum any unnatural interference with the environment of Ninfa and its surrounding properties. The result is a blend of the cultivated and the wild, of the romantic and the rational, and above all a lasting sensation of the mysterious and the sacred.

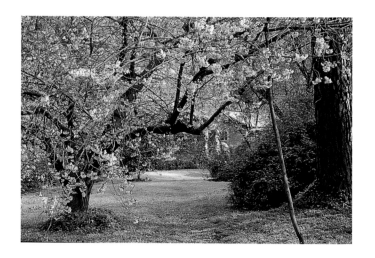

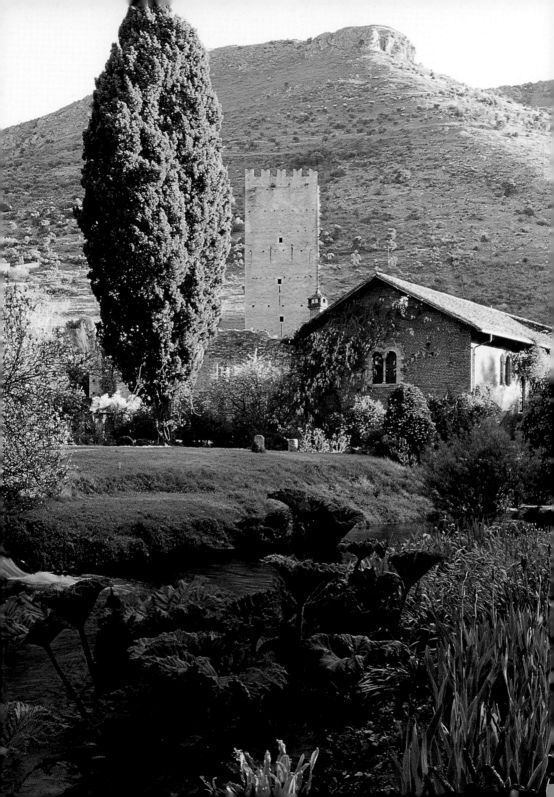

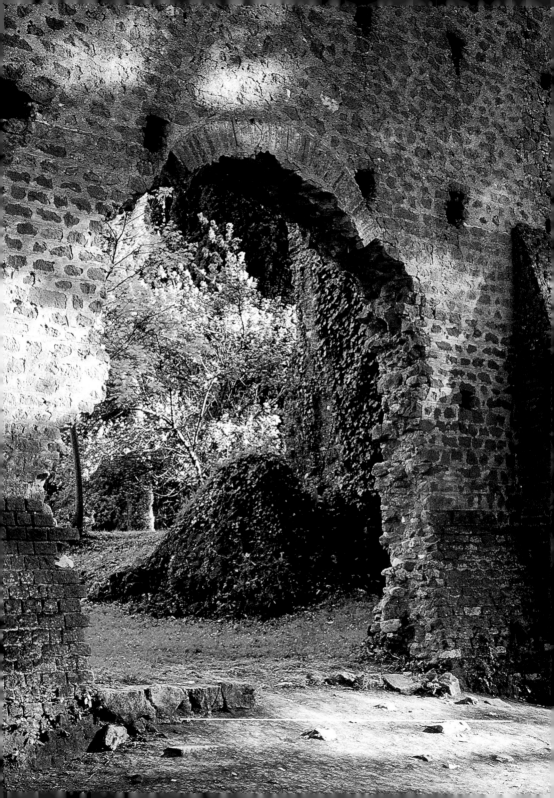

History of Ninfa
and the
Caetani Family

The name Ninfa comes from a little temple built near the spring and dedicated to nymph goddesses in Roman times. Here, Pliny the Elder found inspiration for his poetry and travellers would stop to refresh themselves. In 750 the estates of Ninfa and Norma were acquired by Pope Zacharias, who wanted them not just for their proximity to Rome but also to amplify Church properties and make maximum economic use of them. By that time the estates were vast, stretching from the slopes of the mountains to the sea.

In the eighth century agricultural production in the area was taxed, and it is believed Ninfa became a center for regional organization and administration. During the ninth and tenth centuries it was a frequent stopping point for travellers making their way along the Via Piedemontana between Rome and Naples when the Via

Opposite: The ruined archway leading into the nave of Santa Maria Maggiore, the finest of Ninfa's seven church monuments, where Rolando Bandinelli was crowned Pope Alexander III in 1159.
Overleaf: The brilliant early sunshine at Ninfa, breaking over the mountain, creates strong contrasts of light and shade.

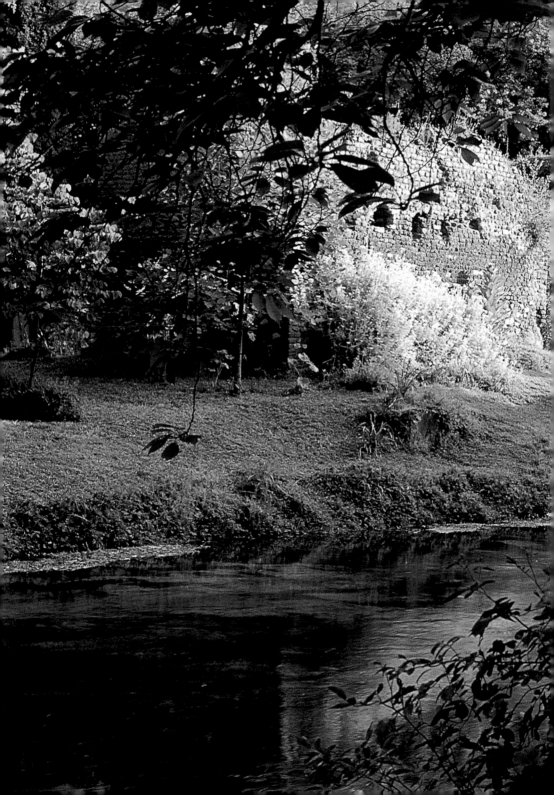

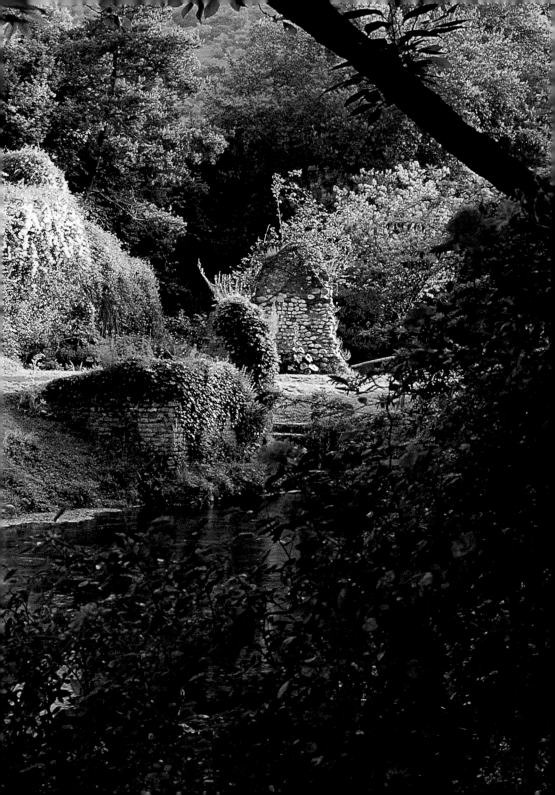

Appia was flooded by the Pontine Marshes. Tolls were routinely levied.

The fortified structure of the town of Ninfa was developed by the various popes of the eleventh century, who were anxious to control the properties and the strategic position. The whole area was richly agricultural and generously supplied with water. At the beginning of the twelfth century Ninfa was more populous than neighboring fortified towns. For several decades it did, however, suffer from the general decline in the Lazio region, and successive pontiffs made land concessions to a number of powerful families in return for money. In 1159 Rolando Bandinelli was crowned Alexander III in the church of Santa Maria Maggiore at Ninfa, whose ruins stand tall to this day.

Sadly, few records documenting life at Ninfa then exist today, but the surviving architecture and frescoes of its seven churches, as well as the fortifications, make it clear that by the end of the century Ninfa had reached a high point in architectural and artistic accomplishment, in commerce, and in military prestige.

In 1213, shortly after the coronation of Innocent III, Ninfa passed to a member of the powerful Conti family, who remained concessionaires for several decades until Cardinal Pietro Colonna gained the fiefdom in 1293 with the support of the Annibaldi. Pope Boniface VIII, a

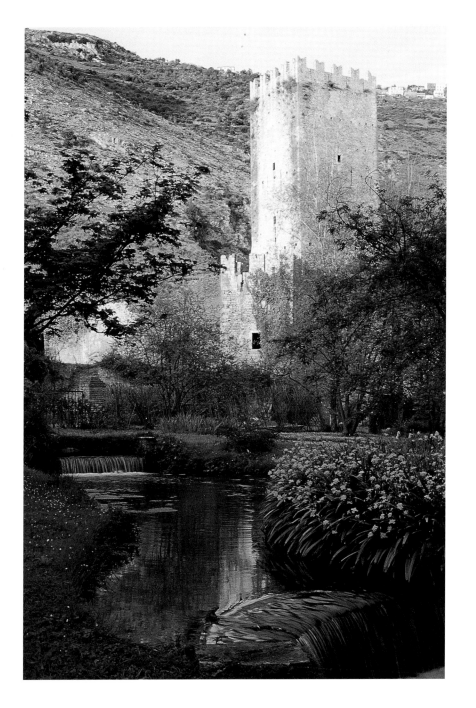

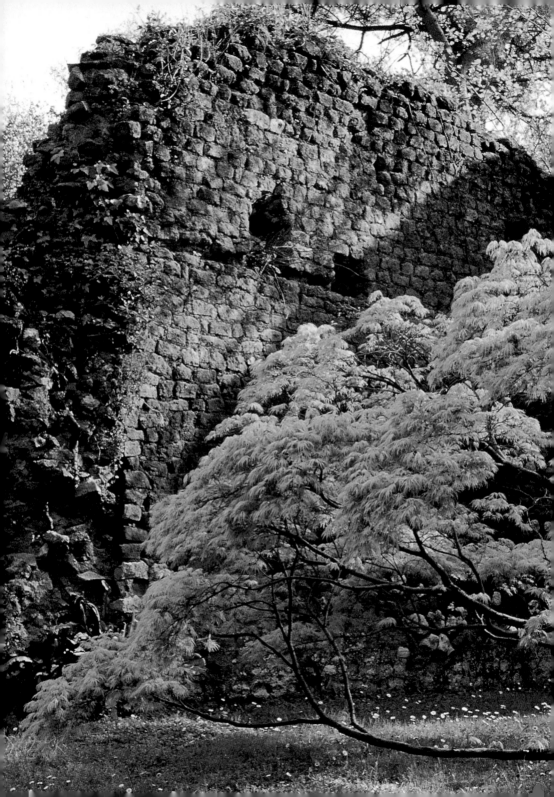

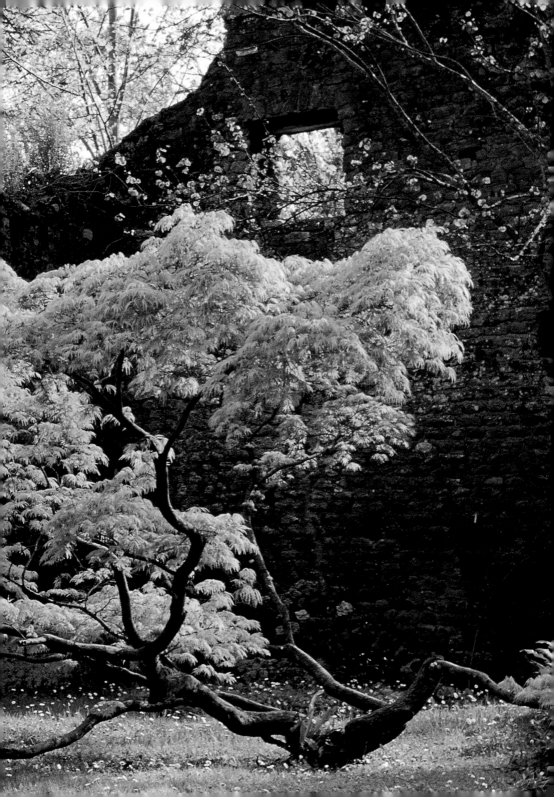

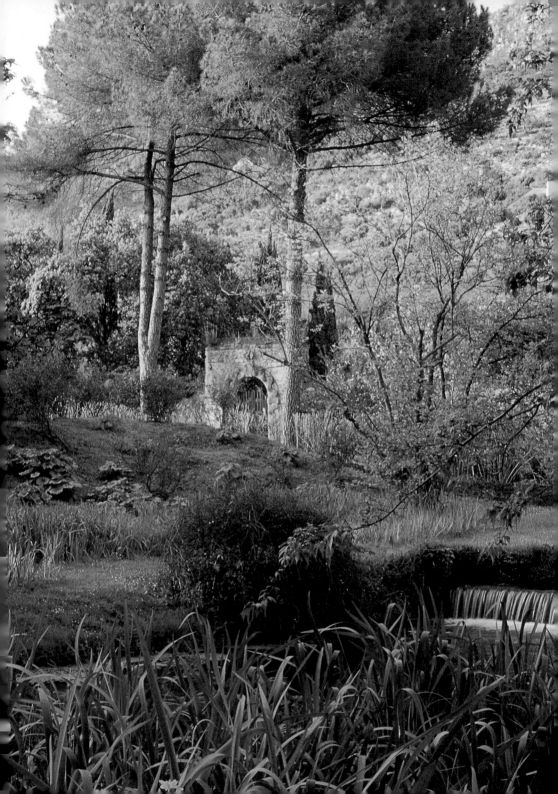

bitter opponent of the Colonna family, bought Ninfa in 1297 for two hundred thousand gold florins and gave it to his nephew Pietro Caetani. With the help of his powerful uncle, Pietro Caetani worked assiduously to improve administration, establishing rules to empower the family still more and to back up their entitlements within a solid legal framework.

With the Caetani family fully in control, Ninfa underwent a profound change that proved economically and commercially beneficial to the population. Farming was given great importance, particularly grain, vegetables, and meat. Other income was derived from fish caught in the river Ninfa and in surrounding canals, and from the cultivation of vineyards. The Caetanis also encouraged the growth of small industries, building various mills at Ninfa to produce flour and oil, and also a tannery for the

Opposite: Two pines (*Pinus pinea*) stand guard on each side of the arched gateway to the hortus conclusus.

Left: Part of the beautiful rock garden, so much loved by Donna Lelia, adjacent to the remains of San Biagio. The rocks and stones themselves were taken from the outer walls of Ninfa, breached for the last time in 1382.

Overleaf: The last stretch of the River Ninfa before it leaves the garden, flowing under the double arches of the Ponte del Macello and out into the nature reserve surrounding Ninfa. It reaches the sea some fifteen miles (twenty-five kilometers) away.

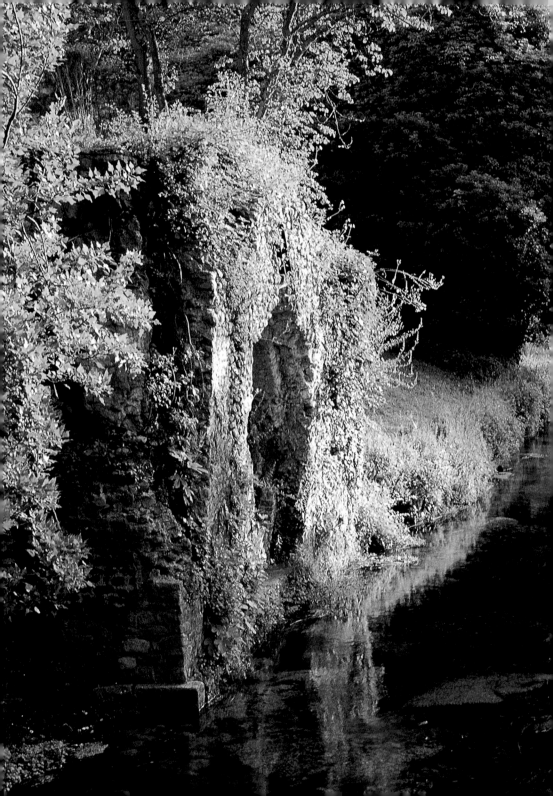

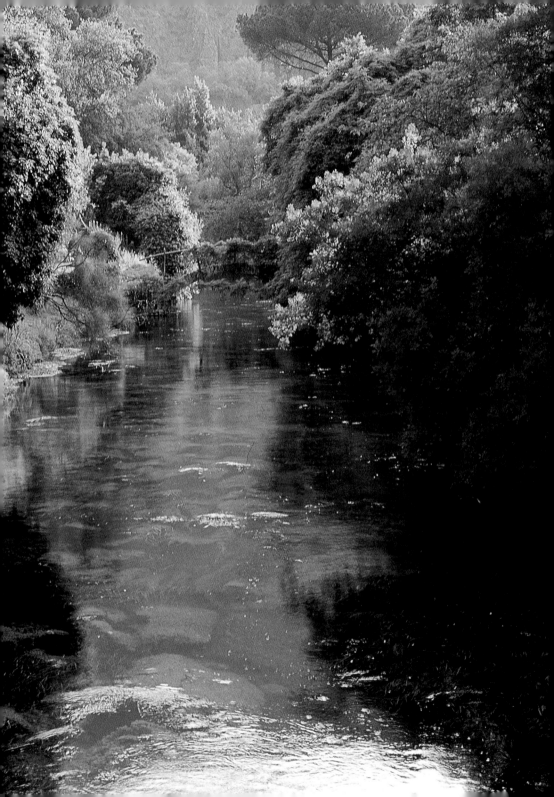

processing of hides. These initiatives were made possible by damming the lake just above the town and passing the water through sluices to drive rudimentary machinery. Today there is an echo of this system in the running of hydroelectric turbines at the head of the river. The abundant water flowing through the town and between the houses also enabled the inhabitants to cultivate many small gardens, turning Ninfa into an oasis, a foresight of how it would look some seven hundred years later.

Under the Caetani family, Ninfa underwent a period of rapid expansion during the thirteenth and fourteenth centuries. At its peak, Ninfa had an imposing double perimeter wall punctuated by fortified watchtowers protecting seven churches, approximately 150 houses, fourteen towers, a castle, a town hall, various mills, and about two thousand inhabitants.

This period of prosperity ended during the civil wars provoked by the Great Schism of the Roman Catholic Church. Ninfa fell to mercenary troops from Brittany and the Basque country, among others, in 1381, during the pontificate of the anti-pope, the so-called Clement VII, who was the challenger to Pope Urban VI and an adversary of the Caetani. Bands from neighboring areas ultimately destroyed Ninfa, and the community ceased to exist. The inhabitants fled in disarray, resettling

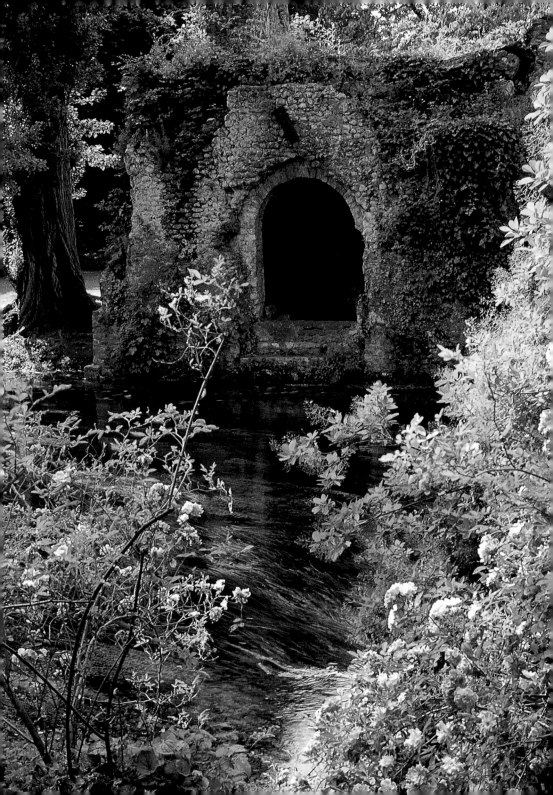

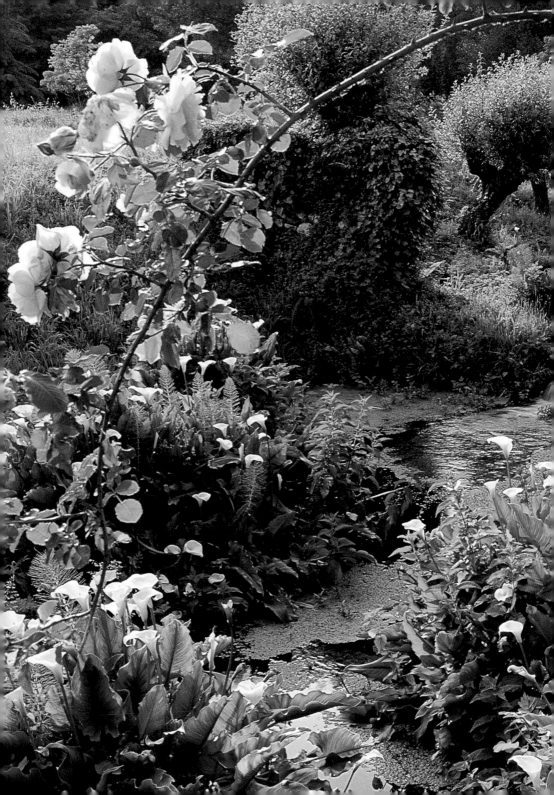

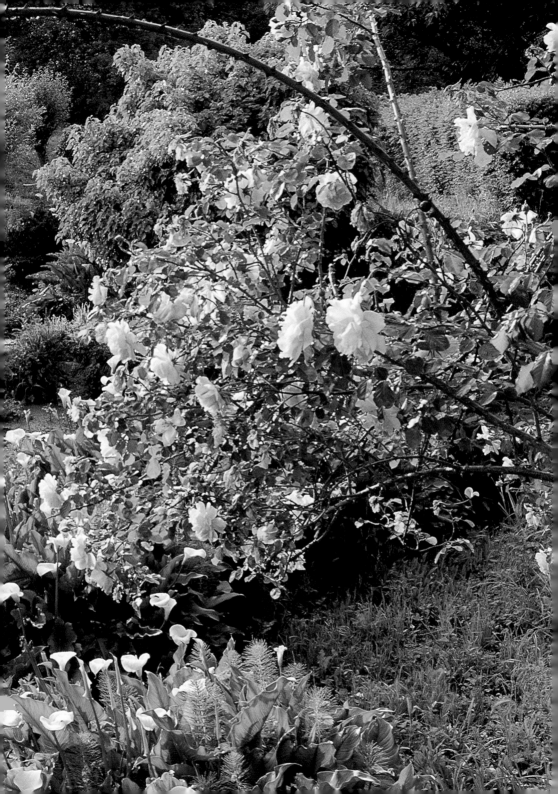

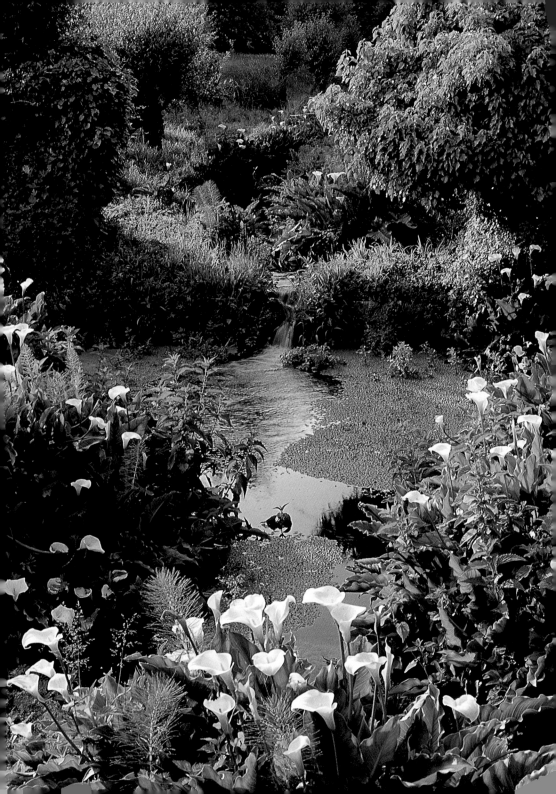

eventually in Sermoneta and other neighboring towns and villages.

For several decades local farmers continued to use the water and the mills, and to quarry for stone. But successive generations of the former inhabitants were afraid of the ruined town, the legendary scene of so much violence and desolation. Later efforts to resettle were frustrated by a strong outbreak of malaria in the region, followed by a radical social and economic deterioration in the area that lasted until quite recently. Ninfa's destiny for six centuries, even though the property remained a Caetani fiefdom, was to be one of silence and oblivion.

Two interesting developments occured between the destruction of Ninfa and the present day. An iron foundry built next to the main water source in 1470 enjoyed some commercial success. In the 1600s Francesco Caetani created a brilliantly conceived formal garden in an area protected by the old walls of the town. This Italianate garden was crossed by hedges and planted with a great quantity of bulbs, particularly tulips. Francesco Caetani was highly cultured and a passionate horticulturist, as well as being both viceroy of the two Sicilies and governor of Milan. As with the Caetanis of the twelfth and twentieth centuries, Francesco was the Renaissance embodiment of the genius for gardening present in this illustrious family.

Opposite: Water is accessible throughout the gardens, not only from delightful streams such as this, but also from man-made canals and a centrally controlled system of underground ducts. All the water flows directly from the lake, which is higher than the garden itself.

37

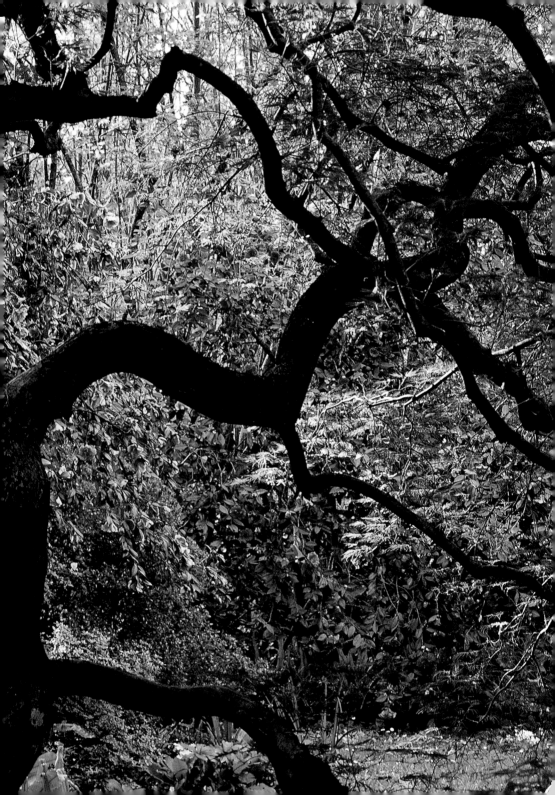

The Garden and the
Last Caetani Owners

From the time of Pietro Caetani, Ninfa and its territories remained in the Caetani family in an extraordinary succession that ultimately revived the fortunes of Ninfa, transforming it from a place of desolation and melancholy to one bursting with life once more.

We pick up the story at the beginning of this century. Times may have changed but not the Caetani family, which, boasting popes, cardinals, political leaders, and men of rare cultivation, continued to exemplify outstanding gifts and qualities and distinguish itself with achievements fit for posterity.

It was Prince Gelasio Caetani who began the restoration and environmental recovery of the forgotten town. This patient architect, writer, and soldier was ahead of his time in techniques of restoration and

Opposite: The angular branches of a maple (*Acer palmatum* 'Dissectum Rubrum').
Overleaf: *Magnolia* x *soulangiana* hangs over one of the ornamental ponds.

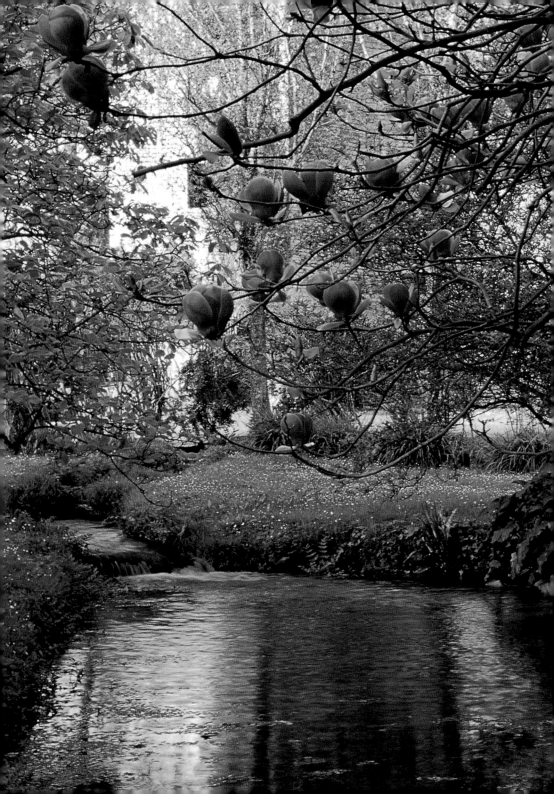

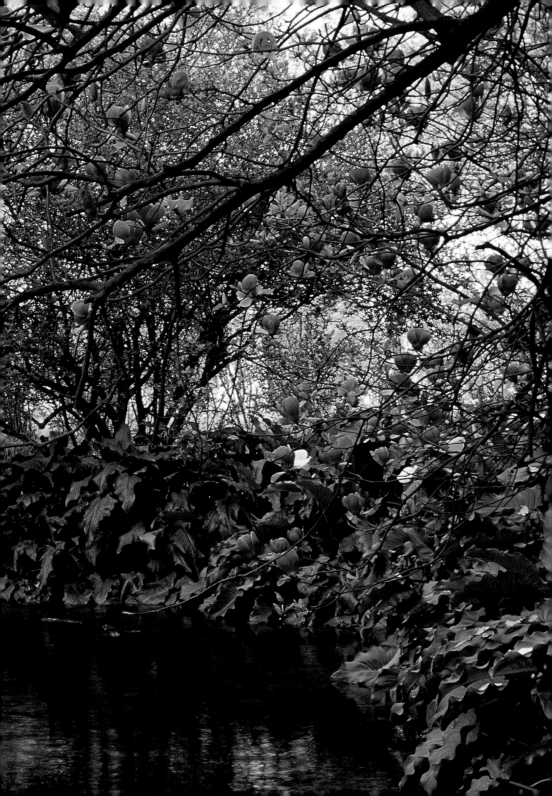

Right: The hedgehog is one of fifteen species of mammal residing at Ninfa.
Opposite: Umbrella pines (*Pinus pinea*) towering over the bamboo plantation.

ecology. With his English mother Ada Bootle Wilbraham, the first of the three celebrated Caetani duchesses to be involved with Ninfa, he cleared the overgrown ruins of the old town and made the original plantings of the tall trees we see today. Gelasio excavated and restored the ancient ruins of houses and churches, using experience gained in his restoration of

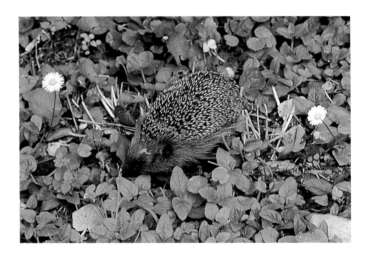

another major Caetani property, the castle of Sermoneta about three miles (five kilometers) to the south. He also undertook the enormous task of writing *Domus Caetana*, the history of the family and its links over twenty centuries to this part of Italy.

After centuries of neglect Ninfa was described in 1860 by German historian Gregorovius as "the Pompeii of the Middle Ages." With just a few trees left and a thick mantle of vegetation covering the ruins, the

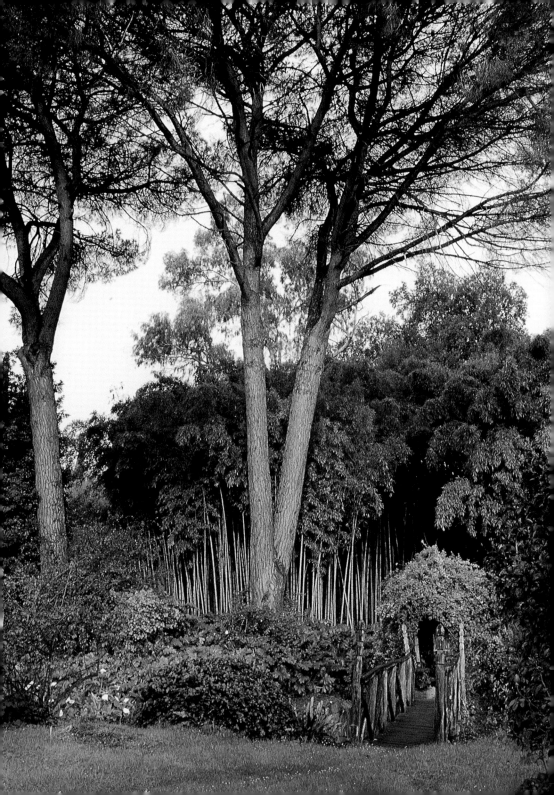

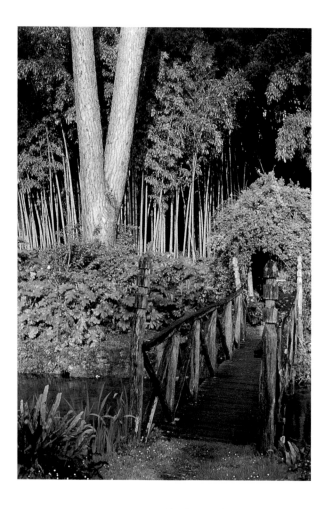

Right: The Ponte di Legno, a favorite observation
and resting point for visitors, weas built in 1947
and most recently restored in 1998.
Opposite: The magnificent bamboo (*Phyllostachys
mitis*) planted by Ada and Gelasio Caetani
in the 1920s, is watered by the purest of all Ninfa's
independent springs.

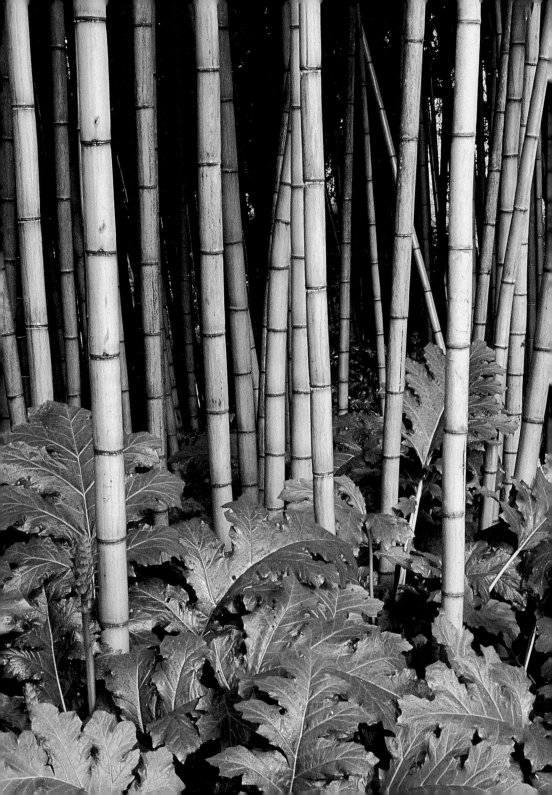

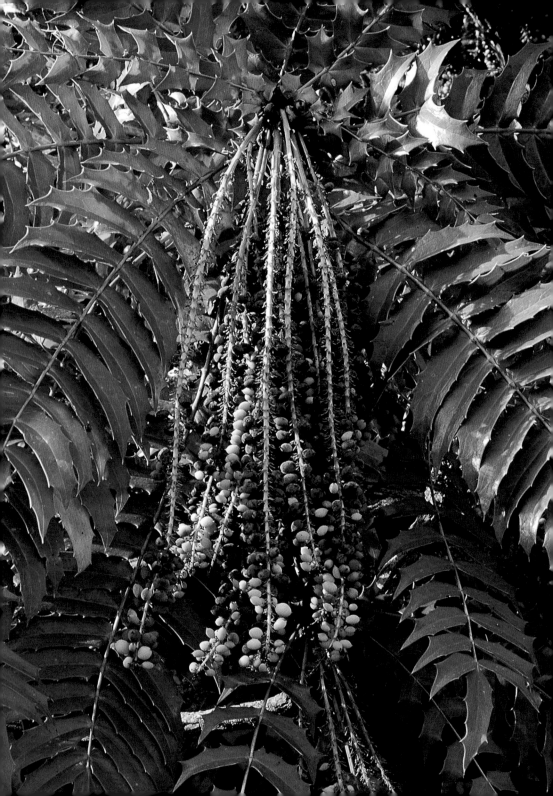

transformation of the ruined town into a romantic
garden required imagination bordering on genius.

As work proceeded in clearing the site and bringing
the waters under control once more, it became obvious
that the emerging garden needed to become part of its
natural setting, complementing rather than dominating
the historic ruins. This meant a predominantly free and
informal style and layout, with little hint of geometric
restraint except in the cypress avenues that follow the
lines of the ancient streets.

The garden was brought into being with such
principles in mind, Donna Ada giving it a distinctly
Anglo-Saxon influence. She was no newcomer to garden
design, and twenty years earlier had created a fine
garden at the family seaside property at Fogliano. She
was expert in the adaptation of plants to new climates,
and imported and cultivated many varieties there. A
fine horsewoman, she reveled in the Pontine
countryside. Unfortunately the estate was incompetently
managed after her time and was virtually abandoned.
Fogliano had all the makings of one of the great nature
reserves of Italy, situated as it is inside the Circeo
National Park next to some of the finest dunes and
beaches in the country.

The principal restoration and recovery work at Ninfa
lasted from the twenties until the early fifties, giving us

Opposite: The winter-
flowering *Mahonia
lomariifolia* seeds itself
freely around the garden.

47

a clear indication of their magnitude. The river was dried out on several occasions to allow the banks to be built up and the bridges strengthened. The 105-foot (thirty-two meter) castle tower was completely renovated, and most of the churches restored along with the old town hall building, later to become the Caetani's country residence. Several fourteenth-century houses were made habitable for the gardeners and their families.

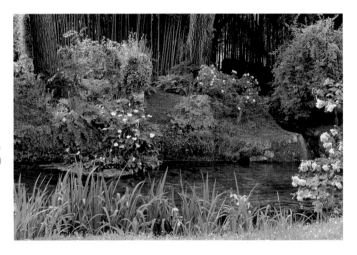

Right: This section of the river bank is backed by an imposing curtain of bamboo.
Opposite: Above all, Ninfa is animated by water, which creates its own often-changing micro-environment for flora of all kinds in this case acquatic iris and *Gunnera manicata*.

Along the line of the ancient street of Ninfa, Gelasio planted numerous cypresses (*Cupressus sempervirens*) the most notable of which are along the Via del Ponte. He also planted cedars (Atlantic and Lebanese) and American walnut (*Juglans nigra*), which he is believed to have introduced while serving as Italian Ambassador to Washington.

The great work continued under Marguerite Caetani, née Chapin, the American-born wife of Duke Roffredo, who had by now inherited the estate from his older brother. Marguerite founded and directed two

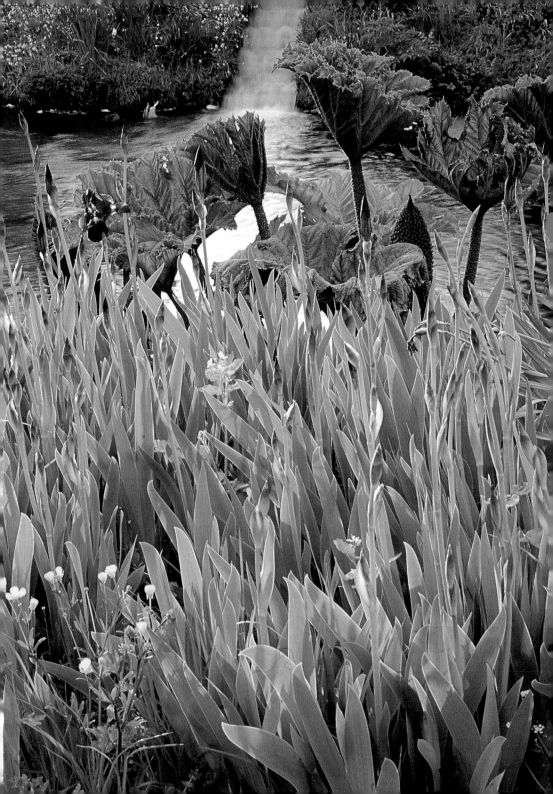

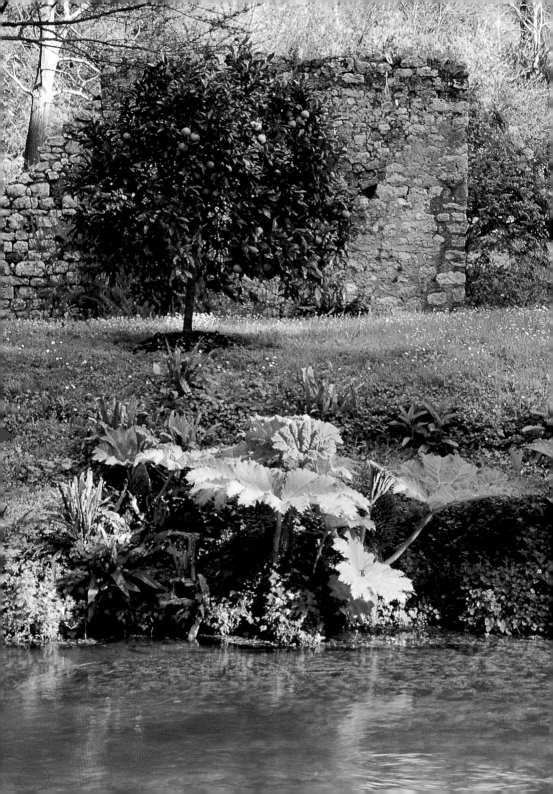

outstanding literary reviews, in which appeared some of the most important writers of that generation. After living in Paris for many years she moved permanently to Rome and became increasingly immersed in the work at Ninfa, expanding and nurturing the garden with great skill and making it a center of inspiration for poets and artists. She planted many of the big magnolias and roses we see today. With her husband Roffredo she designed the distinctive watercourses and waterfalls. Their son Camillo, the last male heir to

Opposite: The three romantic essentials of Ninfa–water, plant life, and ruin–are well represented here.
Below: Many of the ruined houses at Ninfa are garlanded with roses.
Overleaf: The rock garden sloping down into the

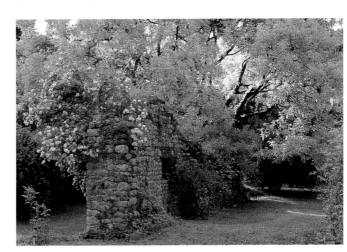

51

Ninfa, died tragically during the World War II.

Thus Ninfa passed to Camillo's sister Donna Lelia, the last of this ancient family, for whom it was to become a consuming passion. In 1951 she married Hubert Howard, himself a member of the Anglo-Italian nobility, who dedicated himself to the administration of the Caetani estates. Lelia is primarily responsible for the appearance of the garden today, but with no loss of the original inspiration and sense of tradition. As a

Piazzale della Gloria. The abundant planting includes verbenas, hebes, salvias, alyssum, annual escholtzias, and miniature pomegranates.

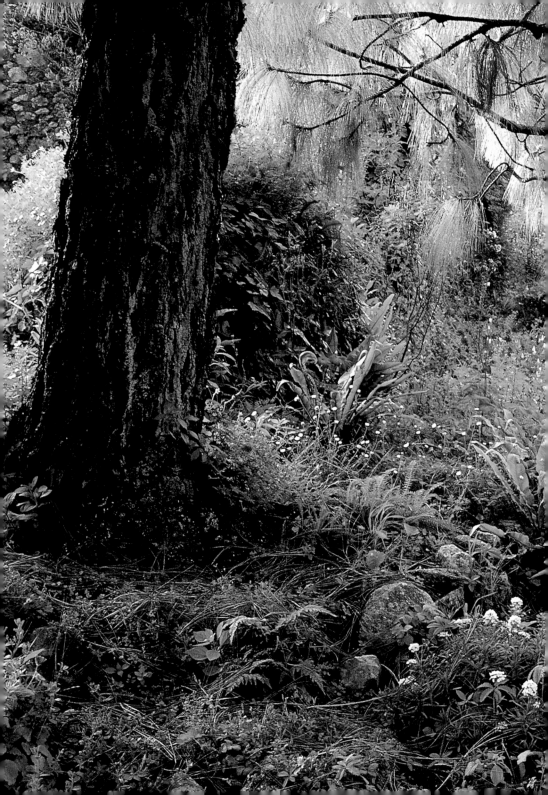

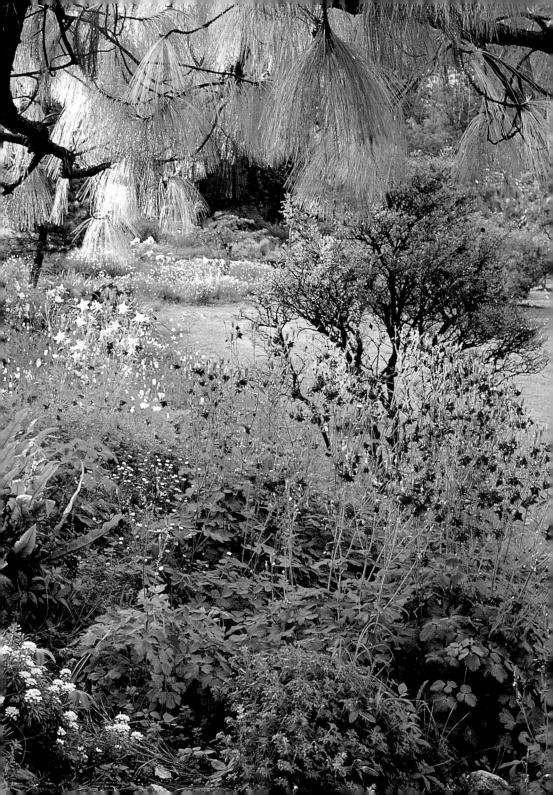

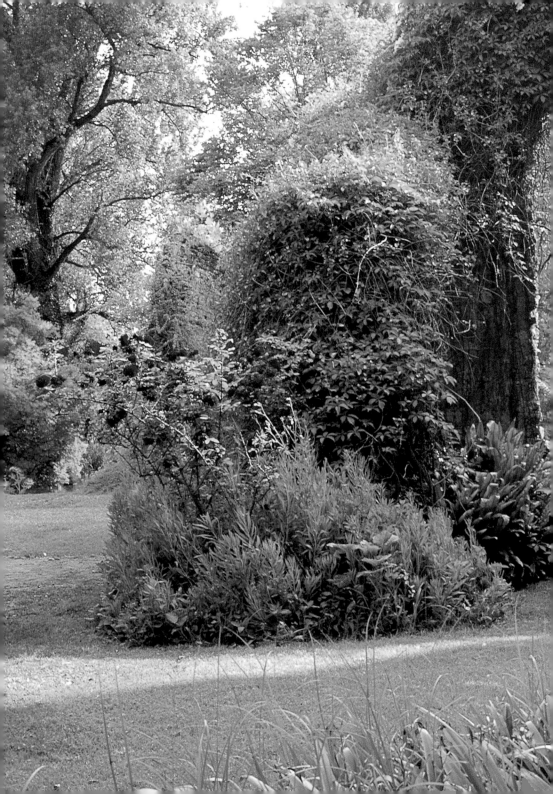

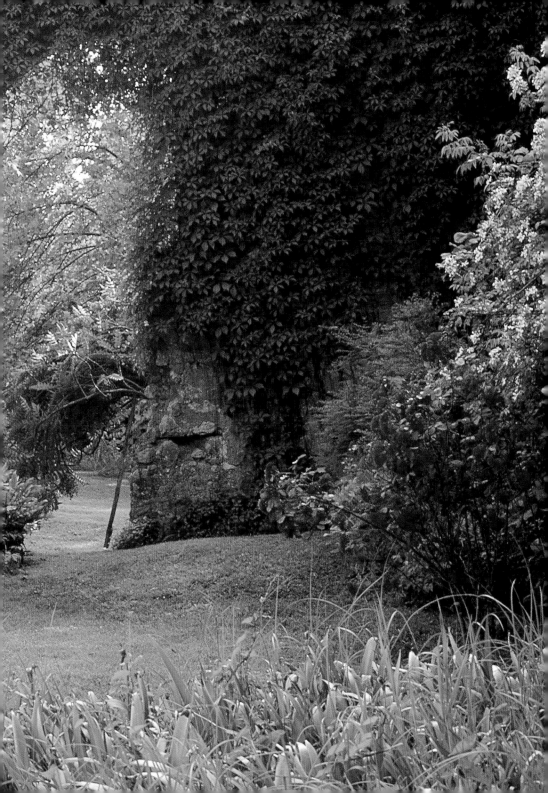

Previous pages: Ninfa shows the spectacular relationship among inspirational planting, good husbandry, and the unique and elegant setting of the ancient town.
Right: Six different varieties of ornamental cherry give long periods of color in the Piazzale della Gloria, one of the most exposed areas of the garden.
Opposite: The basic maintenance of each stone monument, in relation to its surrounding plant life, lies with successive generations of gardeners at Ninfa.

gifted painter she often used her artistic imagination to position trees and plants, always considering color, form, and continuity throughout the seasons. Before her premature death in 1977, Lelia created two foundations to which she left the entire family estate, including Ninfa, the castle of Sermoneta, the farms, and the Palazzo Caetani in Rome, which houses one of the most

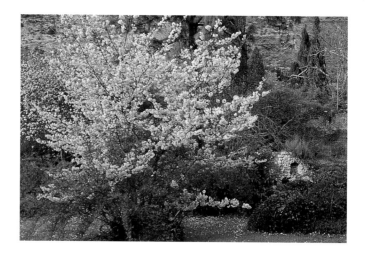

important historical archives in Rome. Hubert Howard became first president of the foundations created by Lelia to own and to manage Ninfa. He died in 1987.

The history of the garden is, then, the history of three extraordinary women who, in a period of seven decades, transformed a wilderness into a resplendent work of art that is now respected, admired, and loved the world over.

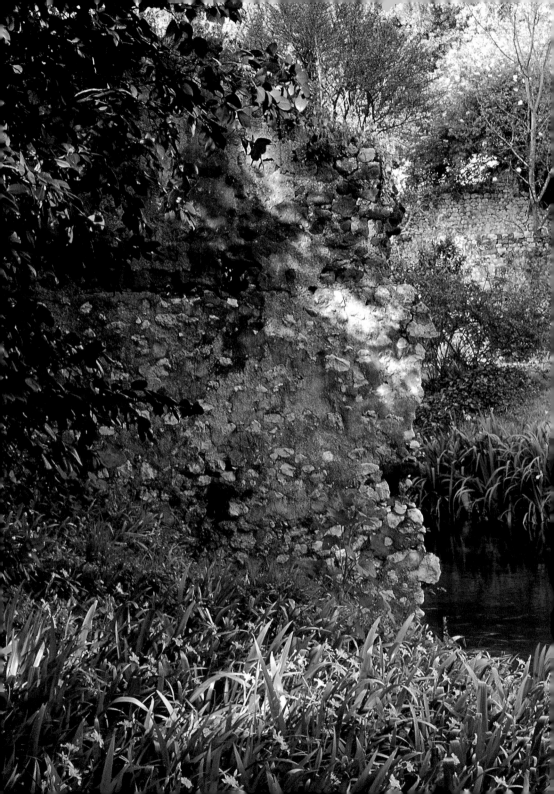

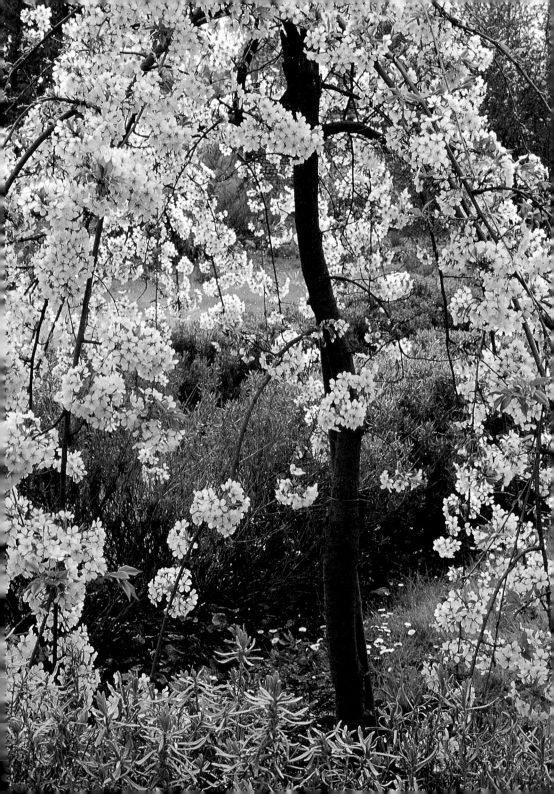

Ninfa Today

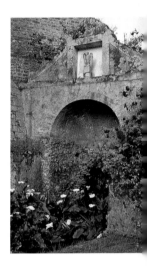

infa does not conform to any specific design or horticultural program. From the beginning spontaneity has been the key, giving visitors the impression of minimal human intervention. Plants are not cultivated unless really necessary, and this factor contributes towards the garden's sense of freedom. Care and husbandry follow the principle of controlled disorder and yet every single plant growing in a ruined building or a hedge, or peeping from a medieval window, is known and cared for. Ninfa cannot be managed along conventional or predictable lines.

Plant care, as Donna Lelia practiced it, was almost secondary to the pursuit of artistic harmony—of greens in the setting of ruins, of colors against stone, and of detail in relation to views and horizons. Visitors often

Opposite: Flowering cherry trees punctuate the lengthy lavender avenue as it crosses the Piazzale della Gloria. *Above*: Francesco Caetani built this classical Renaissance fountain early in the seventeenth century.

Opposite: Magnolia x soulangiana grows to a great size at Ninfa.

speak of Ninfa's sense of mystery. In spite of its breathtaking beauty and horticultural accomplishment, it is the experience of walking through Ninfa that lingers in the memory, even more than the individual highlights.

The garden is not divided into sections, but consists of contrasting moods, sometimes unexpected, at times familiar, but always pleasurable. The different stages in Ninfa's planting history help to explain this. Ada, who started work on the garden in the twenties, planted the tall trees that today provide such a contrast to the majestic ruins of the town and afford shelter to so many plant varieties. Marguerite continued with bright shrub plantings, particularly *Prunus*, *Malus*, and roses, while her daughter Lelia was responsible for the majority of the plants seen today, from climbing rose varieties to shrubs and herbs. She also planted trees just outside the garden boundaries, creating a small arboretum.

Entering the garden from the castle precinct, one is immediately attracted by the sound of racing water from the lake above. In this area are many magnolias including *Magnolia denudata*, M. *Sargentiana*, M. *Sprengeri*, M. *Stellata Rosea*, M. *Campbellii*, M. x *Loeben liebneri*, *Soulengiana* 'Lennei,' and nearby in the birch grove is the large-leafed *Rodgersia*, so rarely found in this climate.

In front of three large copper beeches around the

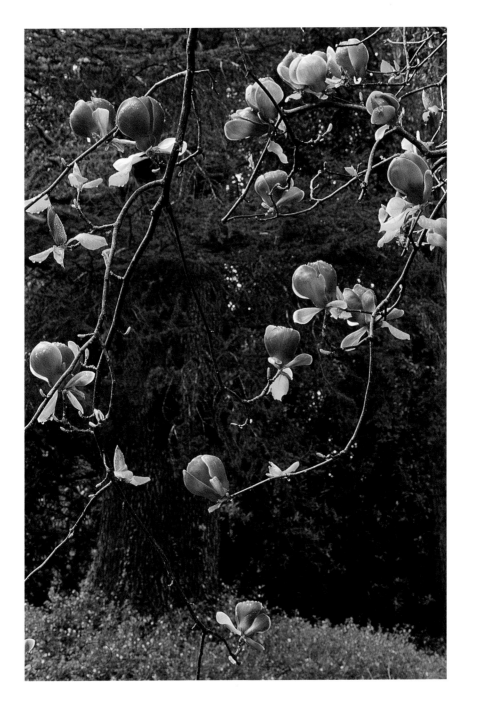

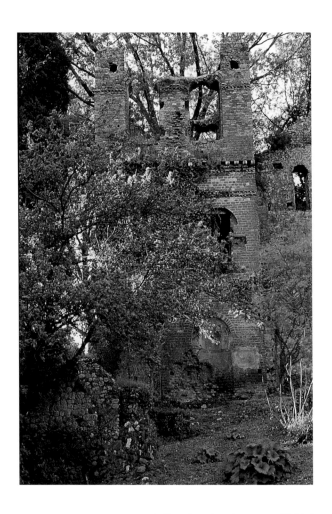

Above: *Ceanothus arboreus*, one of Ninfa's five
spectacular varieties, at Santa Maria Maggiore.
Opposite: In parts of the gardens daisies are allowed
to grow spontaneously in early spring.

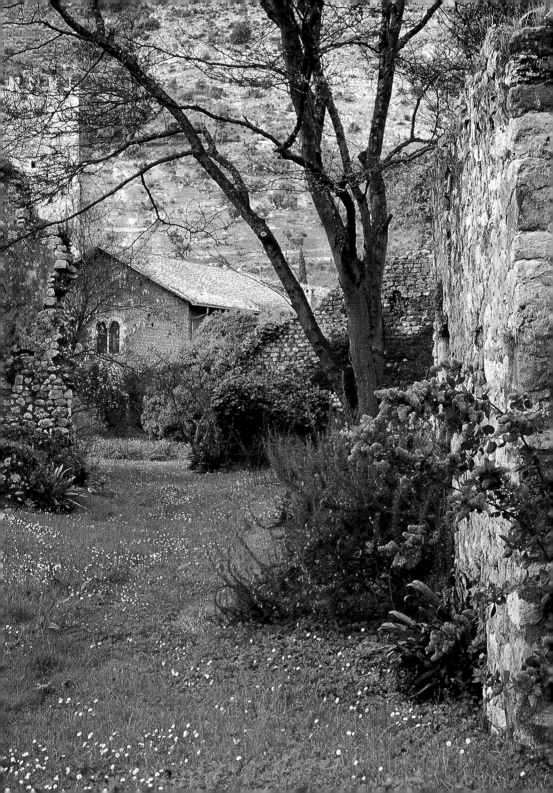

church of Santa Maria Maggiore are flowering cherries *Prunus incisa* and P. x *hillieri*. The lively colors of the flowering cherries make them visible all over the garden, and in certain areas, such as the comparatively open Piazzale della Gloria, there are significant concentrations of them ('*Shirotae*,' '*Taihaku*,' '*Ukon*,' *P. subhirtella* '*Pendula*'). Donna Lelia loved dogwood (*Cornus*), which she planted in the more elevated parts of the garden (*C. Capitata*, *C. Controversa*, *C. Kousa*, *C. Florida*).

Towards the river where the soil is more moist there are a number of maples (*Acer*), planted above all for their autumn colors (*A. Cappadocicum*, *A. Ginnala*, *A. Japonicum* 'Vitifolium,' *A. Palmatum* 'Senaki,' *A. Macrophyllum*, *A. Palmatum* 'Dissectum Atropurpureum'). Spring at Ninfa brings into flower many highly scented shrubs such as *Lonicera fragrantissima*, as well as *Viburnum* (*V.* x *Burkwoodii*, *V.. Farreri*, *V. Plicatum*). Later in the season ornamental apples, sited on a hillock, come into flower (*Malus floribunda*, *M. Hupehensis*, 'Profusion'). This elevated position and the wonderful border of color that they form near the little ponds make this one of the most attractive parts of the garden.

Often, alongside the exposed southern side of the ruins, we find *Ceanothus*, their blue color adapting well

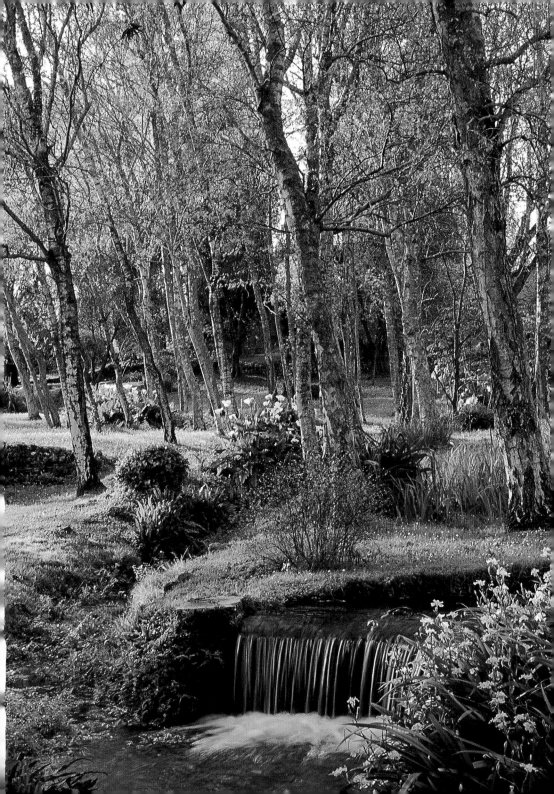

to the soft tint of the stone. Ninfa's stone coloring bears the patina of age. Quarried eight hundred years ago and fashioned by masons, the outside surfaces of the walls take on a wonderful hue. Of the *Ceanothus* the most in evidence are *arboreus* 'Trewithen Blue,' *C. cyaneus, foliosus,* 'Gloire de Versailles,' and 'Indigo.'

The ruins provide ideal climbing surfaces for clematis,

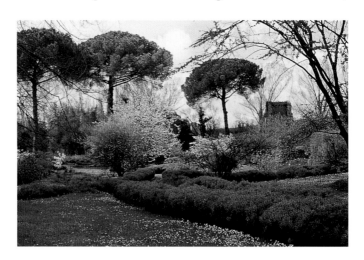

which appear all over the garden. Many are large-flower varieties that can be seen from some distance, including *C. armandii, C. chrysocoma, C. henryi,* 'Lasurstern,' 'Perle d'Azur,' 'President,' and 'Ville de Lyon.'

The river is the life of Ninfa and, though small, it is made more effective by its wooden and stone bridges, pure water, and intense green vegetation and flowering banks. Along with aquatic irises and *Zantedeschia aethiopica* there are great clusters of *Gunnera*

manicata, whose huge leaves can stretch halfway across
the river. Nearer the center of the garden are thriving
plantations of bamboo (*Phyllostachys mitis*), in whose
shade are various ivies and *Acanthus spinosus*. Long
stems of wisteria cross the river, covering whole walls
of the ancient house, including *Wisteria floribunda*
and *sinensis* 'Alba.'

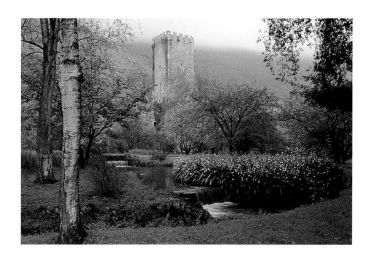

To the west, near the ruined Church of San Biagio,
there is a small hill made from stones brought together
after the outer walls were destroyed. It is known as "the
little hill," and it is here that Donna Lelia created the
rock garden, now one of the most eye-catching features
of Ninfa. Infinite care is required to look after the
hundreds of perennial and rock garden plants, an effort
amply rewarded by the excellent coloring achieved
throughout much of the year.

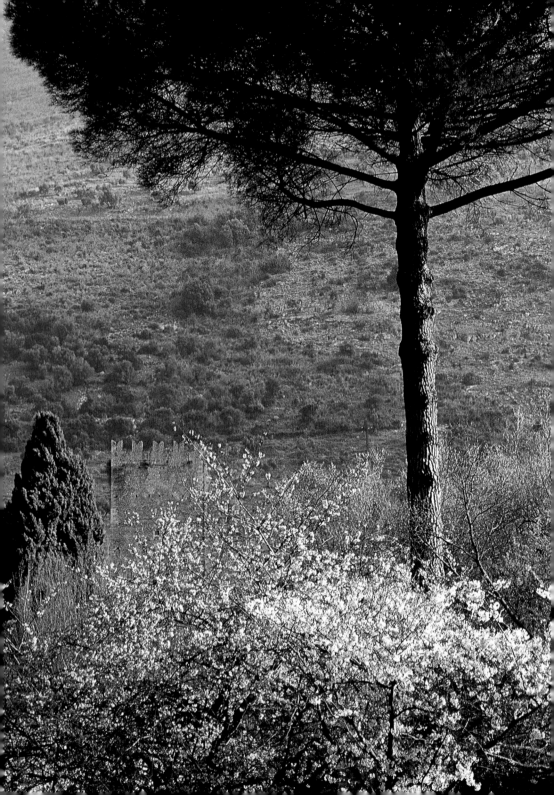

Roses are everywhere–in the avenues, in trees and hedges, along the river, on gates. Some of them flower until October of each year. Especially worthy of mention from among the huge variety are *banksiae* 'Lutea,' *R. bracteata, R. chinensis* 'Mutabilis,' *R. hugonis,* 'Ballerina,' 'Iceberg,' 'Max Graf,' 'Complicata,' 'Penelope,' 'Buff Beauty,' 'Mme Alfred Carrière,' 'Kiftsgate,' and 'Gloire de Dijon.'

Respect for nature's own choices has always been the way of conserving Ninfa's romantic disorder. Spontaneous growth is encouraged–of anemones, cyclamen, daisies, and dandelions. Some of these willingly take root at the very top of certain buildings, such as wild antirrhinums (snapdragon) and cap plants (*Capparis spinosa*). A walk much favored by visitors is the lavender avenue (*Lavandula spica*), which is lined by more than half a mile (more than one kilometre) of lavender hedging. It flowers in June and for two months adds stunningly to the scenic effect.

The mild climate of Ninfa allows tropical plants to prosper, and it is interesting to see the two tall avocado trees in the closed garden created by Francesco Caetani. In this garden, with its recently restored fountains, there is an abundance of fruits, including grapefruit trees (*Citrus maxima*) and, in their shade, raspberries (*Rubus idaeus*).

69

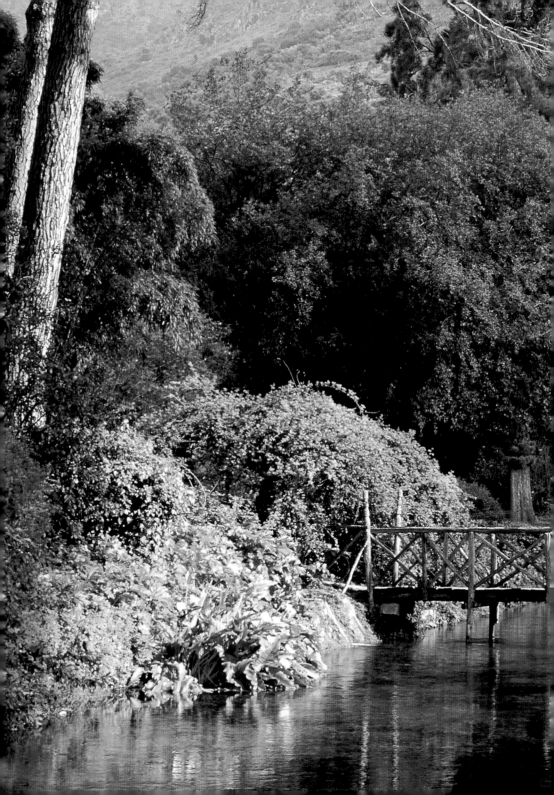

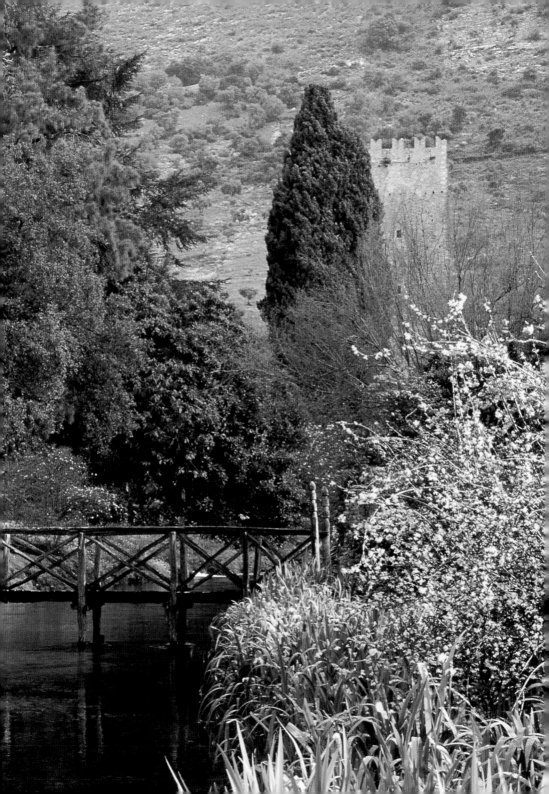

The numerous shrubs at Ninfa are planted not just for their beauty, but also to provide a home for birds and insects. There are many *Buddleia davidii*, which flower beautifully in summer and attract butterflies, and several types of cotoneaster and pyracantha, the vivid winter berries of which provide food for the birds. Bees also have a part in all this, in the pollination of flowers. There are around one hundred bee colonies at Ninfa. From time to time a few will abandon the comfort of their wooden hives and settle in inaccessible places high up in the buildings.

No pesticides are used at Ninfa, and there is little need for them as the earth is healthy. Natural fertilizers are used to strengthen plants and make them resistant to disease. Each gardener at Ninfa is responsible for a specific area, and each prepares the necessary composts.

Care of the ruined buildings and monuments is critical and gardeners carry out minor repairs and other restoration when the garden demands less attention. So important are the ruined walls and buildings, and so integral to the garden, that the role of a "gardener for buildings" has emerged, which in effect means that a member of the garden staff is responsible for the care of those plants, cultivated or native, that flourish among the stones and on the very walls of the ruined buildings.

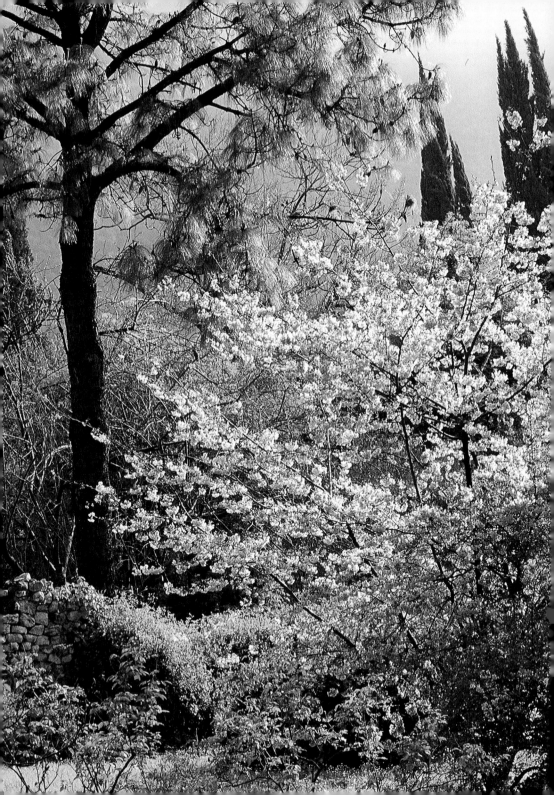

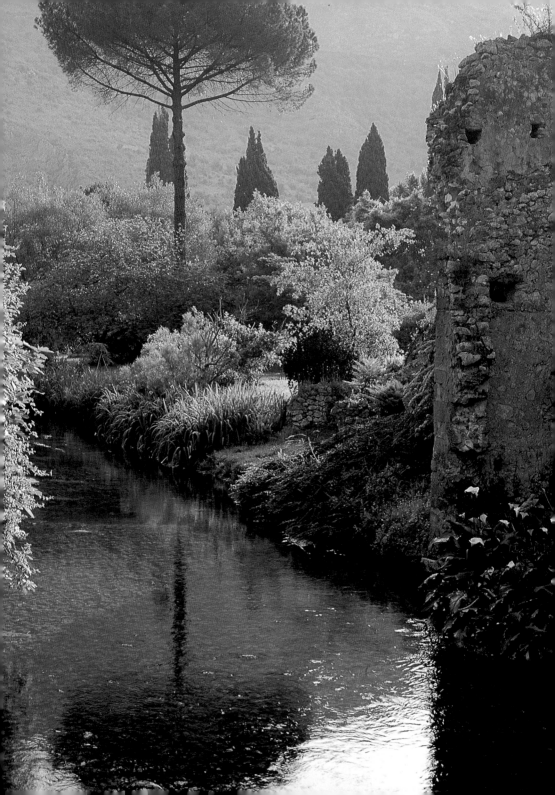

The Future

The future well-being of Ninfa requires goodwill and common sense. More than these, there must continue to be a profound respect for the Caetani family traditions, and a combination of the sensitive husbandry and conscientious management that have served Ninfa so well.

Ninfa is alive with fresh initiatives designed to strengthen and protect the garden well into the new millennium and to conserve the vision of those who created it. An important element of this is the garden's educational value in nature and the environment. This is given first by example, but increasingly through workshops, study groups, and conferences. Also critical is the goodwill of Ninfa's many friends the world over, as well as an abiding sense of the accountability of future generations.

For the latter, the hardest task may well be that of understanding Ninfa for what it really is; that is to say not just an outstandingly beautiful garden but a retreat,

Opposite: This ruined riverside house was once an anchoring point for rowboats entering Ninfa with fruit and vegetables for sale.

75

an inspiration, a cultural stimulus, and an experience. Painters, musicians, poets, experts in restoration and the environment, great gardeners, members of royal households, statesmen, and students—all these continue to visit Ninfa for the inspiration it provides and the magic that it works in them.

Ninfa is often described as a vision of paradise and, indeed, some of the special places in the garden have names fit for their particular beauty: the biggest open space, with its flowering cherries bursting out in a profusion of color, is the Piazzale della Gloria; the area adjacent to the little Roman bridge is known as the "place of good thoughts"; and the wonderful line of hornbeam near the arboretum, forming a gothic vault nearly two hundred twenty yards (two hundred meters) long, is known as "the cathedral."

Ninfa must not just survive, but must prosper. For that to happen, the very quality of intimacy that draws people to it has to be preserved. When the garden was first conceived, as a family retreat, public visits would have been unimaginable, and yet today Ninfa depends on such visits. Over the years the visiting public have come to appreciate the need to limit garden openings to just a few days a month, and for tours to be accompanied by guides. So far this system of benign control has worked well, preserving Ninfa's unique

character and protecting it from physical damage.

With an eye to the future, the wildlife protection area of Ninfa has been dramatically expanded from the original twenty-acre confines of the garden to some thirty-five hundred acres, making it one of the largest and best-known nature preserves in Italy. The thousands of annual visitors, from all over the world, have in turn contributed to the development of a small supplementary economy of significant benefit to the local population.

Foreseeing continued growth in the popularity of the garden and hence in the pressures put upon it, the Fondazione Roffredo Caetani, founded by Donna Lelia to carry on the family's work and traditions after her death, has worked tirelessly in recent years to create a dedicated wildlife park. When complete, this will occupy some two hundred acres adjacent to Ninfa, where many thousands of trees and shrubs have already been planted and where there will eventually be lakes, brooks, and marshes for wildlife. Members of the public will then be able to combine a visit to the park with a visit to the garden, or visit the park independently. In a setting similar to that which would have existed centuries ago, they will be able to enjoy a wonderful variety of wild flowers, migrating birds, and mammals. Another great enterprise will have been completed.

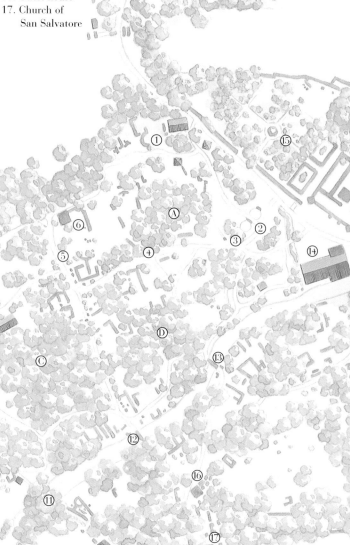

78

Garden Plan and Visiting Information

Ninfa is open to the public on the first weekend of the month from April to October.

Visiting hours are from 9.00 a.m. to 12 noon, and from 2:30 p.m. to 6:00 p.m.

Special group visits are permitted at special rates subject to demand, but detailed applications must be submitted in writing at least three months prior as follows :
La Direzione
Giardini di Ninfa
04010 Doganella di Ninfa
Latina / Italy
tel: 07 73 69 54 04

All tours are accompanied by a guide, and English is spoken.

Parking and all public conveniences, including light refreshments, are available.

There are conveniently located hotels in Sermoneta (Hotel Principe Serrone, tel: 0773 30342), Norma (Hotel Villa del Cardinale, tel: 0773 354611), and Latina, (Hotel Victoria Palace, tel: 0773 66 3966).

Other interesting local attractions include the medieval castle town of Sermoneta, several thirteenth-century monasteries, and the Circeo National Park.

Directions from Rome: Take the SS Pontina, exit to Cisterna, turn south on the Appia, and after 4 kms take a left turn marked Ninfa.

Ninfa is approximately forty-five miles (seventy kilometers) southeast of Rome, and one hundred ten miles (one hundred seventy kilometers) from Naples.

Page 1: The old-fashioned Bordeaux mixture is the only fungicide in use at Ninfa, giving the trunk of this prunus tree its unusual coloring.

Pages 2-3: Spring coloring against the soft tint of Ninfa's limestone, quarried eight hundred years ago.

Pages 4-5: In early times this little bridge, known as the Ponte Romano, provided an alternative crossing over the River Ninfa when the Via Appia between Naples and Rome flooded.

Page 6: A view across the river from the north bank.

Page 8: Ninfa is famous for its vivid spring blossoms, which can peak as early as March. Abundant water allows plants, which would otherwise not survive the severe summer heat of this region, to be irrigated throughout the year.

We should like to express our thanks
to the Fondazione Roffredo Caetani for their generous
collaboration in the production of this book

Series editor Gabrielle Van Zuylen

Designed by Marc Walter / Bela Vista

Copyright © 1999 The Vendome Press
Photographs copyright © 1999 Claire de Virieu
Text copyright © 1999 Lauro Marchetti
Translation copyright © 1999 Esme Howard
Published in the U.S. in 1999 by
The Vendome Press
1370 Avenue of the Americas
New York, N.Y. 10019

Distributed in the U.S. and Canada by
Rizzoli International Publications through
St. Martin's Press
175 Fifth Avenue
New York, N.Y. 10010

Library of Congress Cataloging-in-Publication Data
Cox, Madison.
Majorelle / by Madison Cox and Pierre Bergé ;
Photographs by Claire de Virieu.
p. cm. – (Small books of great gardens)
ISBN 0-86565-210-4
1. Majorelle Gardens (Marrekesh, Morocco)
I. Bergé, Pierre, 1930-. II. Virieu, Claire de. III. Title. IV. Series.
SB466.M83M353 1999
712'.0964'6--dc21 99-30840

Library of Congress Cataloging-in-Publication Data
Marchetti, Lauro.
Ninfa / by Lauro Marchetti and Esme Howard ;
photographs by Claire de Virieu.
p. cm. – (Small books of great gardens)
ISBN 0-86565-205-8
1. Giardino di Ninfa (Italy)
I. Howard, Esme Joy. II. Title. III. Series.
SB466.I83G476 1999
712'.6'0945–dc21 99-30842

Printed and bound in Italy